QUIZPEDIA

EMMA LEWIS

FRIENDS

THE ULTIMATE
BOOK OF TRIVIA

Smith
Street
Books

SO YOU THINK
YOU KNOW ...

SEASON
ONE

Quiz 01

1.
After Rachel leaves Barry at the altar, which wedding gift did she say turned her on more than Barry did?

2.
Which friend of Rachel's ends up going on the honeymoon in Aruba with Barry?

3.
Which Friend has trouble giving up smoking?

4.
What foodstuff does Ross and Monica's nana stockpile in her wardrobe?

5.
Which balloon is a runaway at the Thanksgiving Day parade?

6.
Which Friend once peed themselves while laughing in the seventh grade?

7.
Which actor does Joey almost end up being a "butt double" for in a nude scene?

8.
Who accidentally lets it slip that Ross loves Rachel?

9.
Which Friend participates in a fertility study?

10.
At Chandler's workplace, what does the acronym WENUS stand for?

SEASON TWO

"ISN'T THAT JUST KICK-YOU-IN-THE-CROTCH-SPIT-ON-YOUR-NECK FANTASTIC"

Quiz 02

1.
Which Friend has a superfluous third nipple?

2.
When Joey wants to practice kissing a man for an upcoming role, which Friend ends up kissing him?

3.
Who do Chandler and Joey accidentally leave on a bus?

4.
Which Friend gets chickenpox?

5.
When Joey moves out of the boys' apartment, what is the name of the strange roommate who moves in with Chandler?

6.
In the self-help book that Monica, Rachel and Phoebe read, it suggests that they be their own what?

7.
What does Mr Heckles have in his hand when he dies?

8.
What Christmas gift does Phoebe receive from Joey and Chandler?

9.
When Joey and Chandler play a game of foosball to decide on who keeps the foosball table, who wins?

10.
Where does Chandler lose the bracelet that Joey bought him?

SO YOU THINK
YOU KNOW ...

SEASON

THREE

Quiz 03

1.
What competitive event took place every year at the Geller family Thanksgiving?

2.
What kind of bed does Phoebe accidentally sign for that Monica must return?

3.
Where does Rachel work before landing a new job at Bloomingdale's?

4.
When Joey stars in an infomercial, what product is he selling?

5.
What book does Joey read while Rachel reads *The Shining*?

6.
What is the name of Rachel's boss who Chandler sleeps with?

7.
What new career does Pete choose that results in Monica dumping him?

8.
When Ben becomes interested in a Barbie doll, which toy does Ross encourage him to play with instead?

9.
Which famous actor has Ross just removed from his "freebie list" before running into her at Central Perk?

10.
Which Friend dresses up as Princess Leia?

SEASON FOUR

Quiz 04

1.
In the quiz that sees Monica and Rachel lose the large apartment, what would Joey and Chandler have had to give up if they had lost?

2.
What is the opening line of the song sung each morning by Rachel and Monica's noisy neighbour?

3.
What is the name of the restaurant where all the staff hate Monica?

4.
What is the name of Frank's much older wife?

5.
When Phoebe finds out that she gets to name one of the triplets, which name does she choose?

6.
Whose parents does Rachel meet, while wearing a very revealing outfit?

7.
Which two Friends decide to quit the gym?

8.
When Joey finds out about Chandler and Kathy, what does he make Chandler sit inside as a punishment?

9.
When Joey returns from a fishing trip smelling terribly, whose shower does he use while on a film set?

10.
What sport does Ross play to prove himself to Emily's friends?

SO YOU THINK
YOU KNOW ...

SEASON
FIVE

"THEY DON'T KNOW THAT WE KNOW THEY KNOW WE KNOW."

Quiz 05

1.
What supplies does Monica assign to Phoebe for Rachel's surprise party?

2.
What name does Ross say instead of Emily during his wedding vows?

3.
What is wrong with Joey when he suddenly becomes ill during the triplets' birth?

4.
When Ross decides his New Year's resolution is to try something new every day, which ill-fated item of clothing does he buy?

5.
Who does Ross have a one-night stand with when he finds out Emily is engaged to someone else?

6.
What accessory does Rachel recommend to Joey that leaves the other Friends unconvinced?

7.
Which TV show does Joey star in, but then has all his scenes cut from?

8.
Who accidentally deletes Emily's message from Ross' answering machine?

9.
What habit does Rachel try to take up in order to befriend her new colleagues at Ralph Lauren?

10.
Which Las Vegas casino does Joey end up working at when his film gets cancelled?

SEASON SIX

Quiz 06

1.
Which Friend gets a joke published in Playboy?

2.
What is the name of the fake game that Chandler invents so that Joey can "win back" the money that he owes Chandler?

3.
Who suffers from an unfortunate glow-in-the-dark teeth-whitening incident?

4.
In "The One That Could Have Been", what is Phoebe's occupation?

5.
When Rachel and Phoebe learn self-defence, name the state of "total awareness" that Ross purports to practise?

6.
What does Chandler want to turn the spare room into, but Monica disapproves?

7.
What is the name of the adult film that Joey suspects Phoebe of starring in?

8.
When Ross starts dating Elizabeth, which actor plays her father?

9.
Which wedding venue does Monica put her name on a waiting list for, despite not yet being engaged?

10.
What does Joey accidentally buy at a silent auction?

SO YOU THINK
YOU KNOW ...

SEASON
SEVEN

Quiz 07

1.
Who does Chandler accidentally sit on in the steam room?

2.
Who got ill on a Disneyland ride after eating tacos?

3.
Much to everyone's surprise, which Friend hates dogs?

4.
At Thanksgiving dinner, which US state does Ross list twice?

5.
What does Ross dress up as to introduce Ben to Hanukkah?

6.
What delicious dessert do Rachel and Chandler end up eating off the floor?

7.
Who is the last Friend to turn 30?

8.
When Phoebe takes a job as a telemarketer, what product is she trying to sell?

9.
What kind of award is Joey nominated for but doesn't win?

10.
Who do we find out is pregnant in the final episode of Season 7?

SEASON EIGHT

"EVERYTHING ISN'T MAGICAL? EVERYTHING ISN'T AGLOW WITH THE LIGHT OF A MILLION FAIRIES?"

Quiz 08

1.
What incorrect name does Chandler's colleague keep calling him?

2.
Which actor plays Will, Ross' nerdy friend from high school who grew into a handsome man?

3.
What color was the t-shirt that Ross tries to retrieve from Mona's apartment?

4.
What is the name of the game show that Joey auditions to be the host of?

5.
What are the names of the couple who Chandler and Monica meet on their honeymoon?

6.
What does Ross dress up as at the Halloween party, despite looking "like faeces"?

7.
Which arcade game does Phoebe buy Chandler and Monica as a belated wedding gift?

8.
Who becomes addicted to taking a bath?

9.
What does Joey call the dog that becomes depressed after spending time with him?

10.
Which actor plays Parker, Phoebe's over-enthusiastic date to Ross and Monica's parents' anniversary party?

SO YOU THINK
YOU KNOW ...

SEASON

NINE

Quiz 09

1.
Where does Chandler have to move for work after falling asleep in a meeting then accidentally agreeing to do so?

2.
Which song do Ross and Rachel sing to get Emma to laugh?

3.
Who does Joey set Phoebe up with on a blind date, despite his having never met him before?

4.
Whose birthday is everybody late to?

5.
Chandler's flirtatious colleague Wendy was once voted the second prettiest woman in which city?

6.
Which actor plays Ross and Rachel's male nanny?

7.
When Chandler accidentally finds out that Monica has borrowed money from Joey, what does Joey say Monica has borrowed it for?

8.
Which Friend is dead according to his college alumni website?

9.
What is Emma's first word?

10.
Which eastern European city does Phoebe's ex-boyfriend David live in?

SO YOU THINK
YOU KNOW ...

SEASON
TEN

Quiz 10

1.
What hairstyle is Monica's solution to her frizzy hair?

2.
What was Emma's birthday cake supposed to be shaped like?

3.
Which Friend gets a very unfortunate spray tan?

4.
What product for men does Joey advertise in Japan?

5.
When Chandler and Monica meet Erica to discuss adoption, she thinks Chandler is a doctor and Monica is a what?

6.
Which actor plays the stripper at Phoebe's bachelorette party?

7.
What is the name of the game show that Joey appears on unsuccessfully?

8.
What does Phoebe consider changing her name to?

9.
Erica thinks the father of her baby is either her high school boyfriend or whom?

10.
Who considers buying a house next to Monica and Chandler in Westchester?

SO YOU THINK YOU KNOW ...

ROSS GELLER

Quiz 11

1.
What dinosaur does Ross impersonate during one of his lectures?

2.
What instrument does Ross use during his musical performance at Central Perk?

3.
Where were Ross and Emily supposed to go on their honeymoon?

4.
Who mugged Ross on the streets of New York City, when she was 14 years old?

5.
What is the name of Ross' beloved monkey?

6.
What was the name of the alternative health guru who removed a growth from Ross' lower back?

7.
What was the name of the comic book Ross wrote when he was a child, whose hero had a "superhuman thirst for knowledge"?

8.
What is Ross' occupation?

9.
What is Ross' middle name?

10.
What kind of accent does Ross impersonate to gain credibility at his new lecturing job?

MONICA GELLER

"I'M MONICA. I'M DISGUSTING. I STALK GUYS AND KEEP THEIR UNDERPANTS"

Quiz 12

1.
How does Monica take her scotch?

2.
Who did Monica accidentally share her first kiss with in Ross and Chandler's darkened college dorm room?

3.
What was Monica's imaginary childhood restaurant called?

4.
At what age did Monica first learn to tell the time?

5.
When Monica pretends that she can be messy, what does she leave in the living room overnight to prove how relaxed she is?

6.
What do Judy and Jack turn Monica's childhood bedroom into?

7.
What 1988 event did Monica plan her weight loss for?

8.
Who took Monica to the prom?

9.
Which Thanksgiving food does Monica stick on her head to make Chandler laugh?

10.
Which kitchen items does Monica number in case one goes missing?

SO YOU THINK YOU KNOW ...

PHOEBE BUFFAY

Quiz 13

1.
When Phoebe reports an incorrect deposit into her bank account, her bank awards her $1000 and gives her what gift?

2.
What is the name of Phoebe's Canadian ice-dancing husband?

3.
What is the name of Phoebe's sister-in-law?

4.
Who does Phoebe date until he shoots a bird outside their bedroom window?

5.
What is Phoebe's sister Ursula's occupation?

6.
Which food company was the source of Phoebe's grandmother's famous cookies?

7.
Whose picture does Phoebe's grandmother use to show Phoebe who her grandpa is?

8.
Who gives Phoebe away at her wedding to Mike?

9.
What is the fake name that Phoebe often uses instead of her own?

10.
Phoebe is convinced that someone will die every time she visits who?

CHANDLER BING

"I'M NOT GREAT AT THE ADVICE. CAN I INTEREST YOU IN A SARCASTIC COMMENT?"

Quiz 14

1.
Who is Chandler's *TV Guide* addressed to?

2.
Which song did Chandler dance to, during his days performing in his father's show?

3.
During a blackout, which Victoria's Secret model does Chandler get trapped with in an ATM vestibule?

4.
Whose legs "flail about as if independent of his body", scaring Chandler in the process?

5.
What English synth-pop band inspired Chandler's college hairdo?

6.
When Chandler decides to change his name, what alternative name do Phoebe and Joey propose?

7.
Which one of Joey's sisters does Chandler make out with at a party?

8.
What is Chandler's middle name?

9.
Which actor plays Chandler's erotic novelist mother?

10.
What was the name of the band Chandler and Ross formed in college?

SO YOU THINK YOU KNOW ...

RACHEL GREENE

Quiz 15

1.
What shape is Rachel's tattoo?

2.
Who does Rachel start dating after a blackout occurs in the apartment building?

3.
Who took Rachel to the prom?

4.
What was the name of Rachel's college sorority?

5.
Which younger man did Rachel date before dumping him on her thirtieth birthday?

6.
What high school club did Ross and his friend Will start because of Rachel?

7.
What company offers Rachel a job in Paris?

8.
What is Rachel's middle name?

9.
Which actor plays Tommy, Rachel's very angry date who yells at the chick and the duck?

10.
What would Rachel have changed her surname to if she had married Barry?

JOEY
TRIBBIANI

"COULD I BE WEARING ANY MORE CLOTHES?"

Quiz 16

1.
What did Monica offer Joey when they first met, which he misinterpreted as a code for sex?

2.
Which famous TV soap does Joey star in?

3.
What is the name of Joey's recliner?

4.
Which book does Joey keep in the freezer sometimes because it scares him?

5.
What is the main ingredient of Joey's favorite sandwich?

6.
When Joey is required to be uncircumcised for a nude scene, Monica uses Silly Putty, mushroom, suede, and which deli item to help him complete his scene?

7.
What does Joey always keep in his coat pocket?

8.
What is Joey's middle name?

9.
According to Joey, who is tougher: Mr Peanut or Mister Salty?

10.
Who is Joey's agent?

SO YOU THINK
YOU KNOW ...

FRIENDS
ON
VACATION

Quiz 17

1.
Who gets seriously frizzy hair when the Friends travel to Barbados?

2.
Who wins the final table tennis match in Barbados?

3.
What movie does Joey travel to Las Vegas to star in?

4.
Which member of the British Royal Family does Joey meet in London?

5.
What song does Joey sing to Phoebe on the drive home from Las Vegas?

6.
Who is the only Friend not to attend Ross' wedding in London?

7.
What does Ross ask Joey to bet on in Las Vegas?

8.
Who pees on Monica after she was stung by a jellyfish at the beach?

9.
What was the name of the beer the Friends enjoyed in London?

10.
Who does Joey kick out of the cab while driving over the George Washington Bridge on his way to Las Vegas?

BOY-FRIENDS AND BAD DATES

Quiz 18

1.
What did Monica's creepy ex-boyfriend Howard shout out during intimate moments?

2.
Who does Rachel date who bears more than a passing resemblance to Ross?

3.
Which boyfriend of Monica's turns out to be boring after he gives up drinking?

4.
Which date of Rachel's turns out to be a little too friendly with his sister?

5.
Which actor plays Ursula's ex-boyfriend Eric, who briefly dates Phoebe?

6.
Who is Rachel on a date with when she leaves an answering machine message for Ross that reveals her true feelings for him?

7.
Who dumps Phoebe after finding out she had an open flame in a wooded area?

8.
Who does Rachel briefly date after fogging him with a bug killer in the basement?

9.
How much does Pete tip Monica at the diner?

10.
Which Friend dated Sergei the diplomat?

SO YOU THINK
YOU KNOW ...

GIRL-FRIENDS AND BAD DATES

Quiz 19

1.
What is the name of Ross'
girlfriend who shaves
her head after Rachel
encourages her?

2.
Which Friend broke up
with a woman because
her playful punches were
too hard?

3.
Who breaks up with
a woman because she
screams in her sleep?

4.
Who dates a woman with
the dirtiest apartment in
New York?

5.
Who does Joey date,
even though she thinks
he is actually Dr Drake
Ramoray in real life?

6.
Which girlfriend does
Ross meet when he goes
to China?

7.
What nationality is the
woman Chandler and
Joey fight over while
participating in the
Thanksgiving Geller Bowl?

8.
Which Friend had an
affair with a librarian in
high school?

9.
Who dumps Chandler
after she finds out he has
a third nipple?

10.
Who originally dates Joey
but ends up falling in love
with Chandler?

PETS OF
FRIENDS

"IT'S A CAT" –
"WHY IS IT INSIDE OUT?"

Quiz 20

1.
What type of pet does Paolo have?

2.
What type of animal was the subject of Phoebe's most famous song?

3.
Which childhood pet of Rachel's dies after being dragged for nineteen blocks by an ice-cream truck?

4.
What was the name of Ross and Monica's childhood dog, that went to live on a farm in Connecticut?

5.
What are the names of Chandler and Joey's farm bird pets?

6.
What is the name of Joey's bedtime penguin pal?

7.
What pets do Phoebe and Mike bring to Rachel's birthday party?

8.
What was the name of the cat Rachel buys, that Joey keeps denying is actually a cat?

9.
What kind of pet does Ross think he has accidentally killed while on a date in the messy woman's apartment?

10.
What is the name of the dog that Phoebe brings to Thanksgiving that terrifies Chandler?

SO YOU THINK YOU KNOW ...

THE PARENTS OF FRIENDS

Quiz 21

1.
Where on Long Island is the Gellers' 35th wedding anniversary held?

2.
Jack Geller refers to Monica as his "little ..." what?

3.
What is Chandler's father's stage name?

4.
What is the name of Phoebe's birth mother?

5.
Who goes on an annual fishing trip with their father and returns to New York City reeking of fish?

6.
What is Ross and Monica's mother's name?

7.
What does Phoebe accidentally run over with her car while on a stake-out at her father's house?

8.
What drug is Rachel's mother interested in trying after breaking up with Rachel's father?

9.
What Las Vegas show does Chandler's father appear in?

10.
What is Joey's mother's name?

THE

SIBLINGS

OF

FRIENDS

Quiz 22

1.
How many sisters does Joey have?

2.
Which actor plays Rachel's sister Jill?

3.
How many children does Frank Jr have?

4.
Which one of Joey's sisters had a husband with a restraining order out against her?

5.
How many siblings does Chandler have?

6.
What is the name of Phoebe's twin sister?

7.
What is the name of Dr Drake Ramoray's evil twin?

8.
Which of Joey's sisters gets pregnant and seeks advice from Rachel?

9.
Who is older: Ross or Monica?

10.
Which actor plays Rachel's sister Amy?

SO YOU THINK YOU KNOW ...

THE

FRIENDS

AT WORK

"CHEESE. IT'S MILK THAT YOU CHEW"

Quiz 23

1.
When Monica starts dabbling on the stock market, what is the three-letter name of the first stock she invests in?

2.
What medical condition is Joey's image used for in an awareness campaign?

3.
During the apartment swap quiz, what does Rachel say Chandler's occupation is?

4.
What is the name of the diner where Monica wears a wig, fake breasts and rollerskates to work?

5.
What kind of product is Phoebe's song "Smelly Cat" used to advertise, against her wishes?

6.
What does Ross' colleague steal from him that causes him so much rage that he is forced to take a sabbatical?

7.
When Rachel rescues Chandler from being handcuffed to the chair in Joanna's office, what does she lock him to?

8.
When Joey writes lines for Ross to form an apology to Chandler, he says Ross is "one sorry ..." what?

9.
What kind of college does Frank Jr attend?

10.
What industry does Chandler pursue a career in after giving up his corporate job in Tulsa?

SO YOU THINK
YOU KNOW ...

CENTRAL
PERK

Quiz 24

1.
According to Joey, how many steps is Central Perk away from his apartment?

2.
Which two Friends have worked at Central Perk?

3.
What TV show offers Joey a role that causes him to quit working at Central Perk?

4.
What color is the main couch at Central Perk?

5.
Other than their spots on the Central Perk couch, what do the bullies steal from the group?

6.
Which two famous actors ask the Friends to move over so they can fit on the Central Perk couch?

7.
Who owns Central Perk?

8.
What did Central Perk used to be before it was a coffee house?

9.
What snack does Ross pound with his fist in Central Perk when he is angry at Emily for getting remarried?

10.
Which date of Phoebe's penalises Gunther for a code violation at Central Perk?

SO YOU THINK
YOU KNOW ...

CELEBRITY
GUESTS

Quiz 25

1.
Which famous actor do Monica and Rachel fight over after visiting Marcel on the set of *Outbreak 2: The Virus Takes Manhattan*?

2.
Which comedian plays the restaurateur who gets stoned in Monica's apartment?

3.
Which *Dirty Dancing* star plays Mindy, Rachel's ex-best friend?

4.
Which actor plays Melissa, one of Rachel's sorority sisters from college?

5.
Which actor plays Ryan, Phoebe's "submarine guy"?

6.
Which supermodel plays Joey's temporary roommate and love interest?

7.
Which famous musician does Phoebe date after he recruits her to sing at the library?

8.
Who plays Joey's stalker Erica?

9.
Which actor plays "Susie Underpants", who Chandler dates until she steals all his clothing at a restaurant?

10.
Which famous music artist has a son in Ben's class?

SO YOU THINK
YOU KNOW ...

THE
FRIENDS
SOUND-
TRACK

Quiz 26

1.
What is the first song (other than the theme song) to appear in *Friends*?

2.
Who performs the *Friends* theme song "I'll Be There For You"?

3.
What song is considered to be Ross and Rachel's breakup song?

4.
What romantic song plays during Ross and Rachel's first date at the planetarium?

5.
What song does Ross use to inspire his musical answering machine message when he moves in with Chandler?

6.
What is Chandler and Monica's song?

7.
Which song does Janice sing for Chandler on the mixtape she made for him?

8.
What song is playing while Chandler and Joey realize how much they miss each other?

9.
When Rachel has a fantasy sequence about Chandler, what song is playing on the jukebox?

10.
Which song does Rachel sing at Barry and Mindy's wedding?

SO YOU THINK
YOU KNOW ...

JENNIFER
ANISTON

Quiz 27

1.
In what year was Aniston born?

2.
Who played Aniston's love interest in the 2004 comedy *Along Came Polly*?

3.
For which screen drama did Aniston win a Screen Actors Guild Award for in 2020?

4.
Aniston's father, John Aniston, plays which long-running character on *Days of Our Lives*?

5.
In which 2003 comedy does Aniston star alongside Jim Carrey?

6.
Which ill-fated 1990s spin-off of a popular 1980s teen comedy did Aniston star in?

7.
Which 2002 drama starred Aniston alongside Jake Gyllenhaal and John C. Reilly?

8.
Which heartbreaking 2008 film did Aniston star in alongside Owen Wilson?

9.
Who did Aniston marry in 2000?

10.
Which 2001 Melissa Etheridge music video did Aniston appear in?

SO YOU THINK YOU KNOW ...

DAVID SCHWIMMER

Quiz 28

1.
In what year was Schwimmer born?

2.
Which nostalgic US TV drama did Schwimmer have a recurring role in during its fourth and fifth seasons?

3.
Which 1996 film co-starring Gwyneth Paltrow was Schwimmer's first leading film role?

4.
Who does Schwimmer portray in the 2016 TV series about O.J. Simpson?

5.
Which 2007 comedy was Schwimmer's directorial debut?

6.
In which TV series set in World War II did Schwimmer play Captain Herbert M. Sobel?

7.
In which HBO comedy starring Larry David did Schwimmer appear as himself?

8.
For which 2005 film did Schwimmer provide the voice of the character Melman?

9.
Which 1991 war movie was Schwimmer's film debut?

10.
In which 2012 film about hitman Richard Kuklinski does Schwimmer star as Josh Rosenthal?

SO YOU THINK
YOU KNOW ...

COURTENEY

COX

Quiz 29

1.
Which of Bruce Springsteen's music videos does Cox appear in?

2.
Who did Cox marry in 1999?

3.
Which character on *Friends* did Cox originally audition for?

4.
Courteney Cox was the first person on American television to say "period" during a commercial. Which brand was it for?

5.
What TV show about older women dating younger men did Cox direct?

6.
What did Cox originally study at college before pursuing modeling and acting?

7.
In which sitcom did Cox play Lauren, the girlfriend of Alex P. Keaton?

8.
In the *Seinfeld* episode "The Wife", Cox plays the girlfriend of which character?

9.
In which 1994 film did Cox star as Jim Carrey's love interest?

10.
Which famous 1990s horror trilogy stars Cox as news reporter Gale Weathers?

MATTHEW PERRY

Quiz 30

1.
Perry is a dual citizen of the USA and which other country?

2.
In what year was Perry born?

3.
Which actor plays Perry's love interest in the 1997 film *Fools Rush In*?

4.
In which 2000 dark comedy did Perry play a dentist?

5.
Who plays the 17-year-old version of Perry's character in the 2009 movie *17 Again*?

6.
Which 2015 sitcom did Perry co-develop and star in as lovable slob Oscar Madison?

7.
Which sport did Perry excel in as a young man?

8.
Made in 1988, what was Perry's first film?

9.
What is the name of Perry's character in *The West Wing*?

10.
Which popular TV comedy did Perry both act in and make his directorial debut in?

SO YOU THINK YOU KNOW ...

MATT LEBLANC

Quiz 31

1.
In what year was LeBlanc born?

2.
What was the name of the ill-fated *Friends* spin-off starring LeBlanc?

3.
For what TV series did LeBlanc win a Golden Globe Award in 2012?

4.
Which popular BBC program did LeBlanc co-host between 2016 and 2018?

5.
In 1990 and 2000, LeBlanc appeared in music videos for which band, and also the same band's lead recording artist?

6.
What food product did LeBlanc advertise in 1987?

7.
In 1991, LeBlanc had a recurring role as Vinnie Verducci in which US sitcom?

8.
What is the name of LeBlanc's character in the sitcom *Man with a Plan*?

9.
What is the name of LeBlanc's character in the *Charlie's Angels* films?

10.
Which short-lived 1993 series did LeBlanc guest star in before *Friends* first filmed?

LISA KUDROW

Quiz 32

1.
In what year was Kudrow born?

2.
Which 1997 movie did Kudrow star in with Mira Sorvino?

3.
Which other character does Kudrow perform as on *Friends*?

4.
Which 2005 TV series did Kudrow, write, produce and star in?

5.
Which comedy improv group did Kudrow start her career with?

6.
Which role in *Frasier* was Kudrow originally cast to play, but it didn't work out?

7.
Which other TV sitcom did Kudrow appear as one of her *Friends* characters in?

8.
In which year did Kudrow win an Emmy for *Friends*?

9.
In which 1999 film does Kudrow star as Billy Crystal's love interest?

10.
Who did Kudrow marry in 1995?

SO YOU THINK
YOU KNOW ...

ROSS AND RACHEL

"YOU'RE OVER ME? WHEN WERE YOU... UNDER ME?"

Quiz 33

1.
Where do Ross and Rachel first kiss?

2.
When Ross compiles a list of things he doesn't like about Rachel, what part of her body does he say is "chubby"?

3.
Which colleague of Rachel's causes Ross to become so jealous that they break up?

4.
Who does Rachel immediately start dating after Ross?

5.
What is the name of the girl from the Xerox place who Ross sleeps with when he and Rachel are on a break?

6.
What mean name does Rachel's dad call Ross?

7.
When Ross and Rachel have a brief fling after Chandler and Monica get engaged, what part of Ross' body does Rachel say she misses most?

8.
What is the name of Ross and Rachel's baby?

9.
Where do Ross and Rachel get married, while very drunk?

10.
In Season 5, Ross admits to counting how many times he and Rachel had sex while dating. How many times had they done it?

CHANDLER AND MONICA

Quiz 34

1.
When playing craps in Las Vegas, what do Chandler and Monica say they must roll in order to get married that night?

2.
Which city do Chandler and Monica first get together in?

3.
Which band did Chandler want to have play at their wedding?

4.
When Chandler walks down the aisle, an instrumental version of what song is playing?

5.
What instrument does Ross ask to play at Monica and Chandler's wedding?

6.
When Phoebe is writing a novel, what names does she give the characters based on Monica and Chandler?

7.
What creature does Monica suspect Chandler of having a fetish for?

8.
When Chandler moves in with Monica, he suggests hanging a sign over the bed. What would it say?

9.
Where do Monica and Chandler go on their honeymoon?

10.
Who is the first Friend to find out about Chandler and Monica?

SO YOU THINK YOU KNOW ...

CAROL AND SUSAN

"HI, IS THAT YOUR NOSTRIL? MIND IF WE PUSH THIS POT ROAST THROUGH IT?"

Quiz 35

1.
Which Disneyland attraction did Ross and Carol make out behind while they were married?

2.
What is Susan's surname?

3.
Whose parents refuse to attend Carol and Susan's wedding?

4.
Where did Carol and Susan meet?

5.
Where do Carol and Susan go on vacation to visit their friend, who they say is the first female blacksmith?

6.
Who does Ross suspect Susan of having an affair with when she goes on a work trip to London?

7.
Where do Ross, Phoebe and Susan get trapped while Carol is giving birth?

8.
Where did Ross and Carol meet?

9.
What is Carol's occupation?

10.
Who is the ring bearer at Susan and Carol's wedding?

SO YOU THINK
YOU KNOW ...

GUNTHER

Quiz 36

1.
When Gunther was an actor, how was his character killed off in *All My Children*?

2.
What does Gunther pay Rachel $1500 for in the hope that Rachel would visit him?

3.
Rachel describes Gunther's hair as being "as bright as ..." what?

4.
Which city does Phoebe describe as "a city of Gunthers" because the men are so attractive?

5.
What language, other than English, does Gunther speak?

6.
Who is Gunther's roommate who also works at Phoebe's massage parlour?

7.
Does Gunther appear in 85 or 185 episodes of *Friends*?

8.
What is the name of the actor who plays Gunther?

9.
Who is the only Friend to kiss Gunther?

10.
Who does Gunther almost get to kiss during a game of spin the bottle?

SO YOU THINK
YOU KNOW ...

JANICE

"BY THE WAY, CHANDLER, I CUT YOU OUT OF ALL OF MY PICTURES. SO IF YOU WANT, I HAVE A BAG WITH JUST YOUR HEADS"

Quiz 37

1.
What did Janice have printed on candy hearts for Valentine's Day?

2.
When Janice and Chandler break up, which Lionel Richie song do Chandler and Phoebe sing together?

3.
What is Janice's first husband also known as?

4.
In order to get away from Janice after a fling, where does Chandler tell her he is moving to?

5.
Other than Chandler, which other Friend briefly dates Janice?

6.
What does Joey suggest that Chandler buy Janice as a gift after he finds out Janice is cheating?

7.
What kind of food do Joey and Janice eat during "Joey and Janice's Day of Fun"?

8.
What is Janice's catch phrase?

9.
What is the name of Janice's second husband?

10.
Fearing loneliness, Chandler briefly rekindles his relationship with Janice after reading the high school yearbook of which character?

SO YOU THINK YOU KNOW ...

RICHARD BURKE

Quiz 38

1.
What was the subject of the documentary videos that Monica orders for Richard, that arrive after they break up?

2.
What is Richard's occupation?

3.
Which actor plays Richard Burke?

4.
How many years younger than Richard is Monica?

5.
After the breakup, Monica and Richard run into each other in a video store. What meal does Monica then teach Richard how to cook, that results in them kissing?

6.
What is Richard's ex-wife's name?

7.
Which Friend grows a moustache because Richard has one?

8.
Whose wedding are Richard and Monica attending when they break up?

9.
What gets into Monica's eye and results in her visiting Richard's son at his clinic?

10.
What does Jack Geller refer to Monica as, before he realizes that she is Richard's new girlfriend?

SO YOU THINK
YOU KNOW ...

MIKE HANNIGAN

Quiz 39

1.
What is Mike's occupation?

2.
What is the name of Mike's pretentious mother?

3.
Who sets Phoebe up on a date with Mike?

4.
How many rat babies do Mike and Phoebe end up taking care of after accidentally killing their mother?

5.
When Mike and Phoebe decide to donate to charity instead of having an expensive wedding, what name does Mike use for his part of the donation?

6.
When Phoebe decides to change her name, what does Mike threaten to change his name to?

7.
Which Friend does Mike have a very awkward hang out with?

8.
What was the name of the woman Mike dated briefly after Phoebe?

9.
What is the name of the dog that Mike choses as his third groomsman for his wedding to Phoebe?

10.
How many times had Phoebe been married before she married Mike?

ESTELLE

"HAVE YOU EVER
SEEN ME ECSTATIC?"

Quiz 40

1.
What is Estelle's surname?

2.
Which actor plays the role of Estelle?

3.
Where does Estelle first discover Joey?

4.
What is the name of the casting agent who Estelle suggests Joey sleeps with to get a part?

5.
What small role on *Another World* does Estelle get for Joey after he gets fired from *Days of Our Lives*?

6.
Who does Joey take to the premiere of his movie *Over There*, after Estelle sells all but two of the tickets on eBay?

7.
What does Estelle keep in a dispenser on her desk?

8.
Aside from Joey, who was the Estelle's only other client when she died?

9.
How does Estelle die?

10.
After Estelle's death, who pretends to be Estelle over the phone to reassure Joey?

SO YOU THINK
YOU KNOW ...

THE BIG
APARTMENT

Quiz 41

1.
What color is the inside
of the front door?

2.
Who has a secret
closet filled with junk in
the apartment?

3.
Who rented the
apartment before
Monica moved in?

4.
Who temporarily stayed
in the apartment as
a teenager to attend
dance classes?

5.
What color is the ottoman
that Rachel and Monica
argue over moving?

6.
Who destroys the
bathroom tiles?

7.
How many categories
does Monica use to
organise her towels?

8.
What items do Rachel and
Monica fight over when
Rachel moves out?

9.
What do Monica and
Rachel offer to do for one
minute in order to win
back the big apartment
from Joey and Chandler?

10.
When Phoebe sets up
a doll house to rival
Monica's, which room
does the fire start in?

THE SMALL APARTMENT

"CAN OPEN. WORMS EVERYWHERE!"

Quiz 42

1.
What TV show is watched most in the apartment?

2.
What are the names of the only pets to live in the apartment?

3.
In addition to a drumkit, what Christmas gift does Phoebe buy Joey to try to make Rachel want to move out of the apartment?

4.
What's strange about the pet fish that Eddie buys for the apartment?

5.
What is the only newly purchased item that Joey brings from his fancy apartment back to the small apartment?

6.
Which game do Joey and Chandler play that involves lighter fluid?

7.
Who gets locked in the entertainment cabinet when the apartment is burgled?

8.
Which friend of Chandler's lived in the apartment before Joey?

9.
Who moves into the apartment right after Chandler moves in with Monica across the hall?

10.
Which famous magician plays a traveling salesman who visits the apartment and tries to sell Joey an encyclopedia set?

SO YOU THINK
YOU KNOW ...

ROSS'
APARTMENT

Quiz 43

1.
Who lived in Ross' apartment before Ross?

2.
Other than Rachel, who was the only Friend to live in the apartment with Ross?

3.
What does Monica regularly steal from Ross' apartment?

4.
Which cocktail does Ross get very drunk on in his apartment, when he pretends to be "fine" with Rachel and Joey getting together?

5.
When Ross tries to score the apartment from its former owner, what does he offer as a gift?

6.
Whose retirement fund does Ross refuse to contribute to when he first moves in?

7.
Other than Rachel, who is the only girlfriend that Ross gives a key to?

8.
What does Ross shout at Chandler and Rachel as they help carry his new couch up the staircase?

9.
In addition to "Ross", what does Ross put on his second name tag before his moving-in party?

10.
When he first spots Monica and Chandler making out, what does Ross shout?

PHOEBE'S APARTMENT

Quiz 44

1.
Which household appliance nearly sends Phoebe mad when it won't stop beeping?

2.
What ended up being the cause of the fire at the apartment?

3.
What "pets" do Phoebe and Mike temporarily keep in the apartment?

4.
Who owned Phoebe's apartment before her?

5.
Who is Phoebe's possibly made-up roommate, who she uses as an excuse to prevent Rachel from moving in?

6.
What is the name of the frightening art piece that scared Mike when he moved in?

7.
What is the name of the rat that lived in Phoebe's apartment?

8.
Much to Phoebe's disgust, which store does Rachel buy an apothecary table from?

9.
What is the name of the mouse that lives in Phoebe's apartment?

10.
After the fire, how many bedrooms does the apartment turn out to have?

SO YOU THINK YOU KNOW ...

THE

FRIENDS

KITCHEN

"I'M DONE. WHEW! HERE COME THE MEAT SWEATS"

Quiz 45

1.
What is the name of the completely synthetic chocolate substitute that Monica tries to develop a recipe for?

2.
What beer does Marcel advertise?

3.
What does Monica make in huge batches when she is getting over Richard?

4.
What type of food ends up on the ceiling after Monica finds out that Rachel and Ross broke up?

5.
What does Joey save from what he thought was a bullet, during the ride-along with Ross, Chandler and Gary?

6.
What does Ross call the gravy-soaked piece of bread in Monica's Thanksgiving leftover sandwich?

7.
When Rachel makes a trifle for Thanksgiving, what other recipe does she incorporate?

8.
What type of potato does Joey request Monica make at their first Thanksgiving together?

9.
What does Monica accidentally lose in the quiche when she is catering for her mother?

10.
What fruit is Ross allergic to?

Answers

Quiz 01: 1. A gravy boat 2. Mindy 3. Chandler 4. Sweet'N Low 5. Underdog 6. Rachel 7. Al Pacino 8. Chandler 9. Joey 10. Weekly Estimated Net Usage Statistic

Quiz 02: 1. Chandler 2. Ross 3. Ben 4. Phoebe 5. Eddie 6. Windkeepers 7. A broom 8. Toilet seat covers 9. Joey 10. Central Perk

Quiz 03: 1. The Geller Bowl 2. A racing car bed 3. Fortunata Fashions 4. The Milk Master 2000 5. *Little Women* 6. Joanna 7. Ultimate Fighting Champion 8. GI Joe 9. Isabella Rossellini 10. Rachel

Quiz 04: 1. The chick and the duck 2. "Morning's here, the morning's here" 3. Allesandro's 4. Alice 5. Chandler 6. Joshua's 7. Ross and Chandler 8. A box 9. Charlton Heston's 10. Rugby

Quiz 05: 1. Cups and ice 2. Rachel 3. Kidney stones 4. Leather pants 5. Janice 6. A man's handbag. 7. *Law and Order* 8. Rachel 9. Smoking 10. Caesars Palace

Quiz 06: 1. Ross 2. Cups 3. Ross 4. Stockbroker 5. Unagi 6. A games room 7. *Buffay the Vampire Layer* 8. Bruce Willis 9. Morgan Chase Museum 10. A boat

Quiz 07: 1. Jack Geller 2. Ross 3. Chandler 4. Nevada 5. The Holiday Armadillo 6. Cheesecake 7. Rachel 8. Printer toner 9. A Soapy 10. Rachel

Quiz 08: 1. Toby 2. Brad Pitt 3. Faded salmon 4. *Bamboozled* 5. Greg and Jenny 6. Spudnik 7. Ms Pac-Man 8. Chandler 9. Mozzarella 10. Alec Baldwin

Quiz 09: 1. Tulsa 2. "Baby Got Back" by Sir Mix-A-Lot 3. Mike 4. Phoebe's 5. Oklahoma 6. Freddie Prinze Jr 7. Breast enlargement 8. Ross 9. Gleba 10. Minsk

Quiz 10: 1. Cornrows 2. A bunny rabbit 3. Ross 4. Ichinab, lipstick for men. 5. Reverend 6. Danny DeVito 7. *Pyramid* 8. Princess Consuela Banana-Hammock 9. The Shovel Killer 10. Janice

Quiz 11: 1. Velociraptor 2. The keyboard 3. Athens, Greece 4. Phoebe 5. Marcel 6. Guru Saj 7. *Science Boy* 8. Paleontologist 9. Eustace 10. British

Quiz 12: 1. On the rocks with a twist 2. Ross 3. Easy Monica's Bakery 4. 13 5. Her shoes 6. A gym 7. Thanksgiving 8. Roy Gublik 9. A turkey 10. Mugs

Quiz 13: 1. A football phone 2. Duncan 3. Alice 4. Gary 5. Waitress 6. Nestle Toll House 7. Albert Einstein 8. Chandler 9. Regina Phalange 10. The dentist

Quiz 14: 1. Miss Chanandler Bong 2. "It's Raining Men" 3. Jill Goodacre 4. Michael Flatley's 5. A Flock of Seagulls 6. Gene 7. Mary Angela 8. Muriel 9. Morgan Fairchild 10. Way No Way

Quiz 15: 1. A love heart 2. Paolo 3. Chip Matthews 4. Kappa Kappa Delta 5. Tag 6. The "I Hate Rachel Greene" Club 7. Louis Vuitton 8. Karen 9. Ben Stiller 10. Farber

Quiz 16: 1. Lemonade 2. *Days of our Lives* 3. Rosita 4. *The Shining* 5. Meatballs 6. Luncheon meat 7. A fork 8. Francis 9. Mister Salty 10. Estelle

Quiz 17: 1. Monica 2. Chandler 3. *Shutter Speed* 4. Sarah, Duchess of York 5. "Space Oddity" by David Bowie 6. Phoebe 7. Black 15 8. Chandler 9. Boddingtons 10. Chandler

Quiz 18: 1. "I win" 2. Russ 3. Fun Bobby 4. Danny 5. Sean Penn 6. Michael 7. Vince 8. Danny 9. $20,000 10. Phoebe

Quiz 19: 1. Bonnie 2. Joey 3. Chandler 4. Ross 5. Erika 6. Julie 7. Dutch 8. Ross 9. Ginger 10. Kathy

Quiz 20: 1. A cat 2. A cat 3. LaPooh 4. Chi Chi 5. The Chick and The Duck 6. Huggsy 7. Baby rats 8. Mrs. Whiskerson 9. A hampster 10. Clunkers

Quiz 21: 1. Massapequa 2. Harmonica 3. Helena Handbasket 4. Phoebe 5. Joey 6. Judy 7. A dog 8. Marijuana 9. Viva Las Gay-gas 10. Gloria

Quiz 22: 1. Seven 2. Reese Witherspoon 3. Three 4. Tina 5. None 6. Ursula 7. Dr Stryker Ramoray 8. Dina 9. Ross 10. Christina Applegate

Quiz 23: 1. MEG
2. Venereal disease
3. Transponster
4. Moondance Diner
5. Kitty litter 6. His
Thanksgiving leftover
sandwich 7. A filing
cabinet 8. Polentologist
9. Refrigerator college
10. Advertising

Quiz 24: 1. 97 2. Rachel
and Joey 3. *Mac and
C.H.E.E.S.E.* 4. Orange
5. Chandler's hat 6. Billy
Crystal and Robin
Williams 7. Terry 8. A bar
9. A scone 10. Larry

Quiz 25: 1. Jean-
Claude Van Damme
2. Jon Lovitz 3. Jennifer
Grey 4. Winona Ryder
5. Charlie Sheen 6. Elle
Macpherson 7. Chris
Isaak 8. Brooke Shields
9. Julia Roberts 10. Sting

Quiz 26: 1. "Sky
Blue and Black" by
Jackson Browne 2. The
Rembrandts 3. "With
or Without You" by
U2 4. "Wicked Game"
by Chris Isaak 5. "We
Will Rock You" by
Queen 6. "The Way
You Look Tonight" by

Tony Bennett 7. "My
Funny Valentine" by
Ella Fitzgerald 8. "All by
Myself" by Eric Carmen
9. "Time of the Season"
by The Zombies
10. "Copacabana" by
Barry Manilow

Quiz 27: 1. 1969 2. Ben
Stiller 3. *The Morning
Show* 4. Victor Kiriakis
5. *Bruce Almighty*
6. *Ferris Bueller* 7. *The
Good Girl* 8. *Marley and
Me* 9. Brad Pitt 10. "I
Want to Be in Love"

Quiz 28: 1. 1966 2. *The
Wonder Years* 3. *The
Pallbearer* 4. Robert
Kardashian 5. *Run
Fatboy Run* 6. *Band
of Brothers* 7. *Curb
Your Enthusiasm*
8. *Madagascar* 9. *Flight
of the Intruder* 10. *The
Iceman*

Quiz 29: 1. "Dancing
in the Dark" 2. David
Arquette 3. Rachel
Greene 4. Tampax
5. *Cougar Town*
6. Architecture 7. *Family
Ties* 8. Jerry 9. *Ace
Ventura: Pet Detective*
10. *Scream*

Quiz 30: 1. Canada
2. 1969 3. Salma Hayek
4. *The Whole Nine Yards*
5. Zac Efron 6. *The Odd
Couple* 7. Lawn tennis
8. *A Night in the Life of
Jimmy Reardon* 9. Joe
Quincy 10. *Scrubs*

Quiz 31: 1. 1967 2. *Joey*
3. *Episodes* 4. *Top Gear*
5. Bon Jovi and Jon Bon
Jovi 6. Heinz Tomato
Ketchup 7. *Married... with
Children* 8. Adam
Burns 9. Jason Gibbons
10. *Class of '96*

Quiz 32: 1. 1963
2. *Romy and Michele's
High School Reunion*
3. Ursula 4. *The
Comeback* 5. The
Groundlings 6. Roz
Doyle 7. *Mad About You*
8. 1998 9. *Analyze This*
10. Michel Stern

Quiz 33: 1. Central
Perk 2. Her ankles
3. Mark 4. Russ 5. Chloe
6. Wethead 7. His hands
8. Emma 9. Las Vegas
10. 298

Quiz 34: 1. A hard eight 2. London 3. Swing Kings 4. "A Groovy Kind of Love" by Phil Collins 5. Bagpipes 6. Marcia and Chester 7. Sharks 8. Merge 9. The Bahamas 10. Joey

Quiz 35: 1. "It's a Small World" 2. Bunch 3. Carol's 4. The gym 5. Colonial Williamsburg 6. Emily 7. A janitor's closet 8. College 9. Teacher 10. Ben

Quiz 36: 1. An avalanche 2. Her cat 3. The sun 4. Paris 5. Dutch 6. Jasmine 7. 185 8. James Michael Tyler 9. Phoebe 10. Rachel

Quiz 37: 1. Chan and Jan Forever 2. "Endless Love" 3. The Mattress King 4. Yemen 5. Ross 6. A barium enema 7. Chinese food 8. "Oh my God" 9. Sid 10. Mr Heckles

Quiz 38: 1. The American Civil War 2. Ophthalmologist 3. Tom Selleck 4. 21 years 5. Lasagne 6. Barbara 7. Chandler 8. Barry and Mindy's 9. Ice 10. A "twinkie in the city"

Quiz 39: 1. Pianist 2. Bitsy 3. Joey 4. Seven 5. Mr X 6. Crap Bag 7. Ross 8. Precious 9. Chappy 10. Twice

Quiz 40: 1. Leonard 2. June Gable 3. When he is performing in *Freud!* the musical 4. Lori 5. Cab driver number two 6. Chandler 7. Cigarettes 8. Al Zebooker 9. Coronary embolism 10. Phoebe

Quiz 41: 1. Purple 2. Monica 3. Ross and Monica's grandmother 4. Ross 5. Green 6. Joey 7. Eleven 8. Candlesticks 9. Kiss 10. The aroma room

Quiz 42: 1. *Baywatch* 2. The Chick and The Duck 3. A tarantula 4. It's a Goldfish cracker 5. A large dog statue 6. Fireball 7. Joey 8. Kip 9. Janine 10. Penn Jillette

Quiz 43: 1. Ugly Naked Guy 2. Phoebe 3. Cash 4. Margaritas 5. A basket of mini muffins 6. The handyman 7. Mona 8. "Pivot!" 9. Dr Geller 10. "Get off my sister!"

Quiz 44: 1. A smoke detector 2. Rachel's hair straightener 3. Baby rats 4. Phoebe's grandmother 5. Denise 6. *Gladys* 7. Bob 8. Pottery Barn 9. Susie 10. One

Quiz 45: 1. Mockolate 2. Monkeyshine Beer 3. Jam 4. Fruit 5. A sandwich 6. The Moist Maker 7. Shepherd's pie 8. Tater tots 9. A fake fingernail 10. Kiwi

"OKAY, SHOULD WE GET SOME COFFEE?"

Smith
Street
Books

Published in 2020 by Smith Street Books
Naarm | Melbourne | Australia
smithstreetbooks.com

ISBN: 978-1-92581-171-1

Publisher: Paul McNally
Text: Emma Lewis
Editor: Aisling Coughlan
Designer: Vanessa Masci
Layout: Megan Ellis

Printed & bound in China by C&C Offset Printing Co., Ltd.

Book 138
10 9 8 7 6 5 4 3 2